D1436738

047003

APERTURE MASTERS OF PHOTOGRAPHY

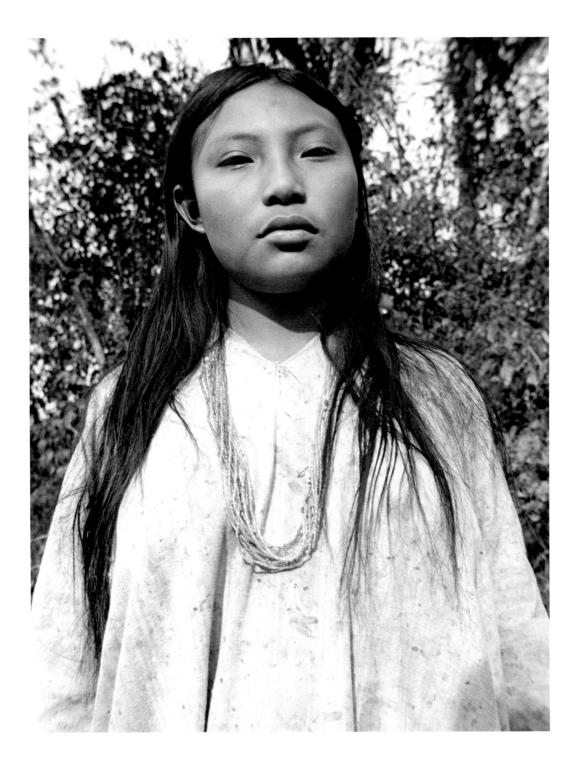

MANUEL ALVAREZ BRAVO

With an Essay by A. D. Coleman

MASTERS OF PHOTOGRAPHY

APERTURE

Frontispiece: Margarita de Bonampak / Margarita from Bonampak, 1949

Grateful acknowledgment to Manuel Alvarez Bravo, the International Center of Photography, New York, and the Witkin Gallery, New York, for the use of original prints from which to reproduce, and to Manuel Alvarez Bravo, Colette Alvarez Urbajtel, Eugenia Rendon de Olazabal, and Cornell Capa, in particular, for their assistance.

Printed and bound in Hong Kong.
Library of Congress Catalog Number: 87-070959
ISBN: 0-89381-742-2

This 1997 edition is a coproduction of Könemann Verlags Gmbh
and Aperture Foundation, Inc.

Aperture Foundation publishes a periodical, books, and portfolios of fine photography to communicate with photographers and creative people everywhere. A complete catalog is available upon request. Address: 20 East 23rd Street, New York, New York 10010. Phone: (212) 598-4205. Fax: (212) 598-4015.

The Aperture Masters of Photography series is distributed in the following territories through Könemann Verlags Gmbh, Bonner Str. 126, D-50968 Köln. Phone: (0221) 93 70 39-0. Fax: (0221) 93 70 39-9: *Continental Europe, Israel, Australia, and the Pacific Rim.* The series is distributed in the following territories through Aperture: *Canada:* General Publishing, 30 Lesmill Road, Don Mills, Ontario, M3B 2T6. Fax: (416) 445-5991. *United Kingdom:* Robert Hale, Ltd., Clerkenwell House, 45-47 Clerkenwell Green, London EC1R OHT. Fax: 171-490-4958. *All other territories:* Aperture, 20 East 23rd Street, New York, New York 10010. Phone: (212) 505-5555. Fax: (212) 979-7759.

For international magazine subscription orders for the periodical *Aperture*, contact Aperture International Subscription Service, P.O. Box 14, Harold Hill, Romford, RM3 8EQ, England. Fax: 1-708-372-046. One year: £30.00. Price subject to change.

To subscribe to the periodical *Aperture* in the U.S.A. write Aperture, P.O. Box 3000, Denville, NJ 07834. Phone: 1-800-783-4903. One year $40.00.

K 2 K4 K6 K8 K7 K5 K3 K1

"[Manuel Alvarez Bravo's] work is rooted firmly in his love and compassionate understanding of his own country, its people, their problems and their needs. These he has never ceased to explore and to know intimately. . . . He wishes to speak with warmth about Mexico as Atget spoke about Paris."

—Paul Strand

"[Manuel Alvarez Bravo's] photographs were enigmas in black and white, silent yet eloquent: without saying it, they alluded to other realities, and without showing them, they evoked other images."

—Octavio Paz

THE INDIGENOUS VISION OF
MANUEL ALVAREZ BRAVO

Popular Art is the art of the People.

A popular painter is an artisan who, as in the Middle Ages, remains anonymous. His work needs no advertisement, as it is done for the people around him. The more pretentious artist craves to become famous, and it is characteristic of his work that it is bought for the name rather than for the work—a name that is built up by propaganda.

Before the Conquest all art was of the people, and popular art has never ceased to exist in Mexico. The art called Popular is quite fugitive in character, of sensitive and personal quality, with less of the impersonal and intellectual characteristics that are the essence of the art of the schools. It is the work of talent nourished by personal experience and by that of the community—rather than being taken from the experiences of other painters in other times and other cultures, which forms the intellectual chain of nonpopular art.

—Manuel Alvarez Bravo

The resonance of credo is unmistakable. Coming from a photographer, these words[1] do not proclaim a personal achievement, but they do indicate his aspirations for photography. Yet Manuel Alvarez Bravo, at long last becoming more widely known outside his native country and the professional world of photography, has in the past sixty years forged a body of work precisely to meet such standards: fugitive, sensitive, personal, nourished by experience, deeply rooted in his culture and his people.

For an image-maker whose work has been known to and admired by Henri Cartier-Bresson, Edward Weston, Paul Strand, Diego Rivera, and André Breton, remaining comparatively obscure through the course of almost two-thirds of a century's work in his chosen medium is no mean feat. One cannot help but suspect that to some extent this is self-imposed, born of a "fugitive" or reticent nature and a consistent avoidance of personal publicity. Insofar as it appears to be voluntary, I find myself loath to violate that privacy.

Yet there are other factors to consider. One of these is his remarkable absence, until very recently, from virtually all the standard reference works on photographic history. (Indeed, he remains unmentioned in even the very latest edition of Beaumont Newhall's magnum opus.) Some attention seems in order, if only to acknowledge what has been achieved. Additionally, his work assumes that photography is an explicitly demotic visual language, to whose fullest progressive range he is committed.

This is not to be understood as "socialist realism" in any sense. Alvarez Bravo's imagery does not deal in stereotypes; his awareness of and response to the ethos of Mexican culture is far too complex and multi-leveled to permit such over-simplification. There is a commitment to people on the lower social strata inherent in the persistent address of

Alvarez Bravo's vision to their experience, and implicit in his uninterest in the middle and upper classes. Certainly this is intentional, and emblematic of his politics. But the work is free of slogans and generalities. Viewers of photographs may tend to generalize from them—sometimes at the photographer's instigation, often independently, and always at their own risk. But one of photography's unique functions is to describe particulars. That aspect of the medium is essential to Alvarez Bravo, for he uses photography as a probe, an incisive tool for uncovering the heart of a culture embodied in the individual people who form its base.

In referring to photography as a demotic language, then, I am not suggesting the establishment of some simplified, standardized politico-visual code and its imposition on all those who would communicate through photographs. Put it this way: there are many dialects at the disposal of the photographer; his/her choice thereof is also a choice of audience. To speak in the language of the elite, the *hieratic* form of a language (Mandarin in China, for instance) is to restrict one's messages to a particular class. Voicing one's thoughts in the common tongue, the *demotic*, points them in the opposite direction. With Alvarez Bravo, we have someone who—to extend the linguistic analogy—is fluent in both Mandarin and Cantonese, but chooses the latter to convey his messages.

That is an illuminating and instructive stance for a photographer to adopt. It merits scrutiny at this juncture because the definition of photography is currently being reshaped by a variety of cultural forces. One of those forces is the contemporary art world, whose relationship to photography at present might best be described as carpetbagging. In the art world microcosm, two theories contend for supremacy. The first, an aloof formalism, argues for the self-referentiality of creative activity; its postulate is that "in the last analysis the main subject matter of art is art." Ostensibly antagonistic to this position, yet not all that far from it, is the fashionable despair of postmodernism, whose thesis is that artistic invention (if it ever existed) is now exhausted, leaving no alternative but endless recycling; it is a cynical vision of culture as flea-market, artist as shopper. Something may be learned by assessing these notions in light of an approach to photography that is integral to its medium yet at the same time directly contradicts both of them.

The purposefulness of that contradiction is made quite explicit in the statement from Alvarez Bravo quoted at the beginning of this essay. We are face to face here not with a naif artist, but with an intentionally indigenous vision.

The distinction is significant. Cumulatively, Alvarez Bravo's deceptively simple images form themselves into a mosaic, an expansive lyric suite or tone poem. This poet's style is one of quiet, conversational intimacy, eschewing bravura, its virtuosity subsumed under the rhythms of a gradual unfolding. Here is one of those bodies of work that requires the viewer to step into what a colleague of mine calls "a bubble of slow time"—in this case, a particularly heat-baked, sun-soaked, thick-shadowed, southern-hemisphere variety of slow time.

Like his craftsmanship, his sophistication conceals itself. Yet it is apparent—from images such as *Somewhat gay and graceful* and *Good reputation sleeping*—that he is adept in both the responsive

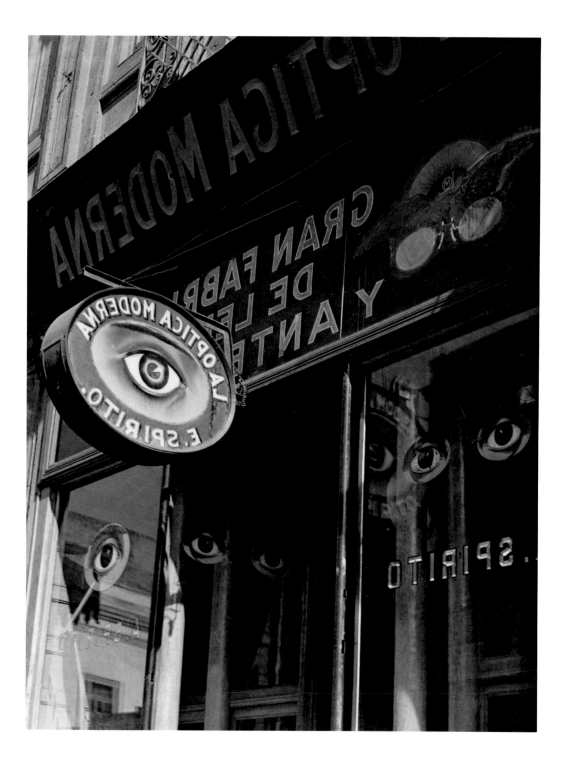

mode, as in Cartier-Bresson, and the directorial mode of photography, as in Meatyard. Other images (*The crouched ones, Unpleasant portrait, Stretched light,* for example) indicate his grasp of the medium's translative capacities—the exploitable differences between what is in front of the lens and what the combination of camera and film will or can be made to register. His sense of formal structure excited Weston, most especially his *Boy urinating.* His recognition of the camera's versatility as a visual means for creating and describing symbolic relationships can be seen in photograph after photograph: *Angels in truck, Mayan boy of Tulum.* In works such as *Optic parable* he demonstrates that he is fluent enough to create elegant, intricate puns—which James Joyce termed the highest form of language.

In short, his imagery displays highly conscious formal underpinnings. This extends into his approach to the photographic print as well. Virtuoso printmaking as such has never been a main thrust of Alvarez Bravo's work. His images are never so dependent on the print as a vehicle that their poetry is lost in ink reproduction; indeed, I suspect that he has deliberately worked toward an imagery that could convey its essentials even in the form of mediocre halftone printing, so that it could be readily disseminated and made accessible to its central subjects, the people of Mexico. Yet he is in fact a master craftsman. Whether cast in color or in such monotone forms as silver bromide and palladium prints, Alvarez Bravo's imagery is full of delicate tonal interaction and subtle chiaroscuro. Certainly one of his constant subjects could be said to be the Mexican light itself—an exorbitant light, a light that appears in his images as a living agent, capable of overwhelming with its brutality, caressing with its lavishness and lust for detail, whispering resonantly in the dark shadows of its own absence.

Alvarez Bravo's work also shows a structural kinship with other workers in his medium. There are connections with Aaron Siskind and Brassaï to be found in his studies of walls. Weston, with whom he corresponded at Tina Modotti's instigation, surely affected him. He shares Clarence John Laughlin's fascination with graveyards. Paul Strand compared him to Eugene Atget in his love of place; the Czechoslovakian surrealist Josef Sudek is another parallel in that regard. To this list I would feel impelled to add Robert Doisneau, Brassaï again (though from a different angle, that of his feel for the miniature dramas of street life), and most of all André Kertész: all three have in common with Alvarez Bravo a responsiveness to nuances of human gesture and interaction.

Aside from his portraiture, Alvarez Bravo's images of people are quite unlike the posed, stylized studies of a Bruce Davidson or a Paul Strand. Rather, they are swift, sharp glimpses of the physical manifestations of personal identity, outlined with clarity and without cynicism. Though sometimes ambiguous, as such manifestations can be, their duality is not exaggerated by the photographer. Like Doisneau, Brassaï, and Kertész, Alvarez Bravo is able to make the viewer feel fully present at events by his attunement to other people's rhythms. Himself falling in step with the tempos of their lives in the process of making his images, he thereby allows the viewer to stand awhile in someone else's shoes, observant but unobserved. His concentration is on those instants when human beings—usually alone or in small groups—reveal

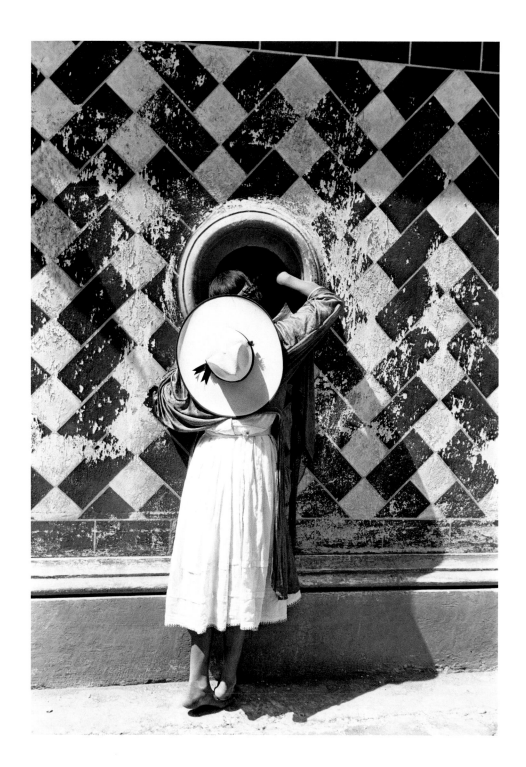

through their bodies something distinctive about their relationship to the earth, to others, or to themselves.

Alvarez Bravo is anything but unaware of art forms outside his own. He is an authority on Mexican mural art (which he has photographed officially for many years). His peers are the modern masters—Diego Rivera, José Clemente Orozco, David Alfaro Siqueiros, et al.—who often posed for him. His work has long been known to the surrealists, and he has surely learned from them in turn. (Witness his use of titles that do not merely reiterate the image contents but instead specify and/ or extend their metaphorical implications: *Placed trap* (page 87), *Landscape and gallop* (page 13), *Posthumous portrait* (page 69), for example.)

Yet the major force which has shaped his imagery has not been art, but culture. The themes around which his work revolves are quintessentially Mexican, motifs so traditional as to be more unavoidable than chosen. What are his predilections? Dogs and dreams, ladders and walls, birds, people, earth, and death.

Given a body of work as extensive and interrelated as Alvarez Bravo's, it is difficult to single out individual images for examination. Ideally, one should be able to refer the reader to a wide, representative cross-section. This is only now becoming possible, thanks in part to the present volume, a few of its predecessors (unfortunately out of print), and a surge of recent one-person exhibitions.[2] Let me, then, discuss a few images for what they might suggest of the whole .

I begin with one of a man lying face upward on the earth. From the sheer volume of blood which has poured out of his mouth and nose to spatter his clothing, pool under his head, and soak into the soil, I would assume that he is dead. However, the small sharp gleam of light in the corner of his left eye suggests in a most disconcerting way that his life continues. The cause of death is not apparent; it may have been external violence or internal hemorrhage. He seems at rest; his body is stretched out, his expression is not fearful or contorted. The photograph brings the viewer close to him, close enough to study his profile and note the details of his clothing—but not so close as to cut him off above the groin or to amputate his slightly curled left hand.

Aside from the man himself, his blood, and the earth, there are no other "contents" in the image, except for some dim folds of cloth in the background and the hint of another's hand or foot in the upper left corner. Instead of making his image at more of a distance (thus distancing the viewer equally from the event), or portraying the body in relation to other people at the scene (giving it more of a public quality), or looking down from above the body (with the overtones of superiority/ triumph that would add), the photographer's choice of position places the viewer at the dead man's left side, the side closest to his heart, inches from his hand, crouching or kneeling—the place of a doctor, a friend or relative, a mourner.

I have always felt a powerful upward thrust in this image, as though the prone body were on the verge of rising horizontally from the ground. With the image turned on its side so that his head is at the top, the man seems quite alive and intent, his body rushing forward into space like Mercury's. Perhaps this response has to do with the counterpoised diagonals of the image's structure, or with

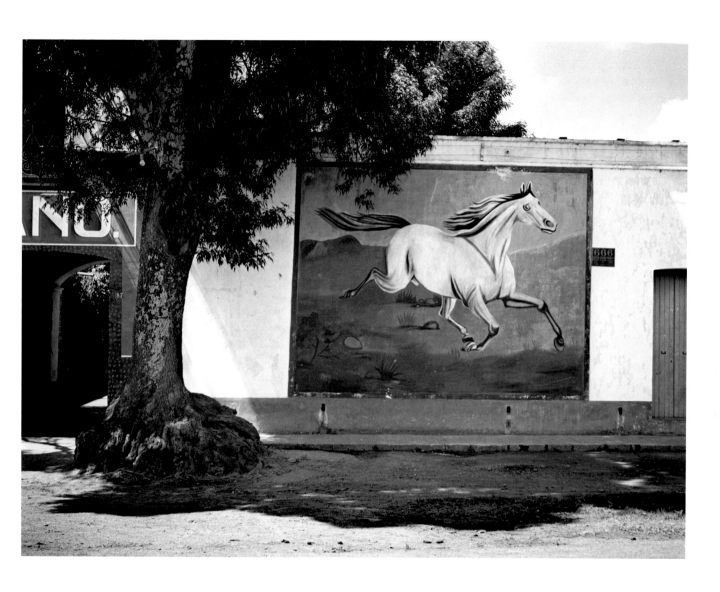

13

the almost aerodynamic flow of his hair and blood.

So, by itself, the image suggests the unexpected death of a seemingly average young man, a death accepted with a certain equanimity; it indicates the cyclical inevitability of the body's return to the dust by depicting that quite literally; it accepts that cycle of the flesh stoically. Yet the vitality of the figure and of the image itself implies some transcendence of the spirit. By itself, we might think of this image as a memorial.

But the image has a title: *Obrero en huelga, asesinado* (*Striking worker, assassinated*), 1934. The title is strictly—and, for Alvarez Bravo, rigorously—informational. The information it offers us could not be deduced from the image. We might have guessed that the man was a worker; we could not have known that he was on strike, nor surely that the cause of his death was political, not accidental. Yet this title does not contradict the impression of the image; instead it elaborates it by providing the context in which to ponder this particular death, a context in which the symbolism of the image echoes, reverberates, expands. From the combination of the two—the visual data in the image, the verbal data of the caption—we are free to write out our own equations.

Though it was never intended to function photojournalistically, this particular image is, in the context of this body of work, untypically topical—almost an *hommage* to the great documentarian of the Mexican Revolution, Augustin Casasola. However, this is only one of many images by Alvarez Bravo in which death is the central issue. His work is full of tombs, cemeteries, coffins, the cadavers and skeletons of various creatures, and the religious/ceremonial artifacts with which mortality

is celebrated in Mexico. If mortality—seen as the return to dust—is central to Alvarez Bravo's art, then this image is surely the epicenter, the one which brings him (and us) closest to the moment of transition from life to death. From it radiates outward much of his imagery: the diverse visions of death; people and animals lying on the ground, drawing sustenance from their soil in order to nourish it in turn; people laboring on or in the dirt, always in contact with it.

The photographer offers no escape from that connection. Walls pretend to divide and control the earth, but they continually crumble—reminding us of their earthy origin—or diminish the human protagonist. Ladders offer a way of climbing, but only for a time: they are always connected to the earth, often at more than one end, as is indicated in the ironic *Ladder of ladders*, 1931, in which a ladder leads upward to a child-sized coffin on a shelf. Only birds get to leave the earth, and even they are eventually snared by death (as in *Twilight bird swayed by the wind*, 1932), brought down at last.

If there is no escape, there is a least one release: dreaming. It is another recurrent motif in Alvarez Bravo's work: *Dreams are for believing (Quevedo)*, 1968, *Dogs bark while sleeping*, 1966, *Good reputation sleeping, 1938, The day dream*, 1931,[3] are a few of the images in which it figures. But we might use *The dreamer*, 1931, (page 29), as an exemplification, if only because it dovetails so precisely with *Striking worker, assassinated*.

In this image also a man lies face upward on the earth. There is grass around his head and feet, but he appears to be on top of a ledge, or perhaps the uppermost of several stone steps. He is lying on his right side. In many ways he resembles the

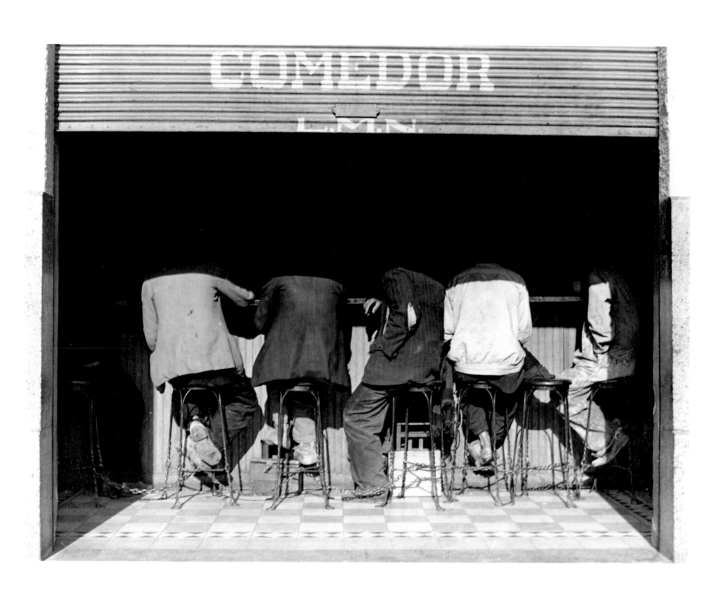

striking worker: for if he is unshaven and poor, he is also at rest, facing the sky, hair flowing back to touch the ground. They even look somewhat alike: about the same age and size.

Through the camera we are positioned on the same level as the dreamer—or, rather, he being at our eye level, somewhat below him. We are also somewhat farther back from him than we were from the worker; the difference is no more than a foot or two, but it is enough to show him full length and also enough to insulate his reverie from the intrusion of camera and photographer.

Unlike the worker, who stares with open eyes into a harsh, flat light, the dreamer's eyes are closed and brushed, like much of his body, with a gentle, mellow glow of sun. Perhaps it warms him enough to make him dream of making love; perhaps that is why his left hand (again, unlike the worker's) is tucked between his closed legs, pressed against his sex. It is that possibility, at least, which Alvarez Bravo asks us to consider.

So they are different, the worker and the dreamer; and yet they are alike. I think it is important to recognize that Alvarez Bravo acknowledges both these realities in his work. Each person he portrays is an individual, and the photographer gives to each one his or her personal identity through his attunement to the subtleties of gesture, posture, and expression. Yet they resemble each other, bound together by their indigence and their share in an ancient culture.

The photographer's sense of the complexity of this issue is summed up in another image. It portrays two men at work on a beach. They stand face to face, the one on the left reaching for a basket of sand on the head of the other. Were it not for that difference in gesture, they could be mirror images of each other: their hats, their short pants, their bodies, their stances are identical. One can imagine them as twin brothers, or children who grew up together as friends in the same community, under the same circumstances, and who have grown so like each other from being polished to an identical smoothness by the same shared experiences. It seems unlikely that they could come to differ radically from each other, that their lives could ever change. Yet they enact this eternal Sisyphean ritual with the assurance and grace of solo dancers. Alvarez Bravo names them *Los mismos—The same.*

Immersed in culture, yet devoid of sentimentality, Alvarez Bravo requires that his work have emotional and intellectual accessibility as well as formal logic, continuity, and growth. His imagery may be fugitive, but it is not secretive. Though he speaks in the vernacular with eloquence, his perceptions inevitably transcend what Latin American critics have termed, disparagingly, the merely "folkloric." There is little of the specifically autobiographical in Alvarez Bravo's photographs; instead, their authenticity springs from intuitions and understandings of his themes whose basis is an embrace of cultural experience. He is a paradigm of the rare, invaluable photographer who chooses to serve as the eye of his people—and who, by probing into the heart of his own culture so as to bear witness to its vitality, exposes something of the essence of all human experience.

Despite his single-minded focus on his homeland, there is nothing either anthropological or pa-

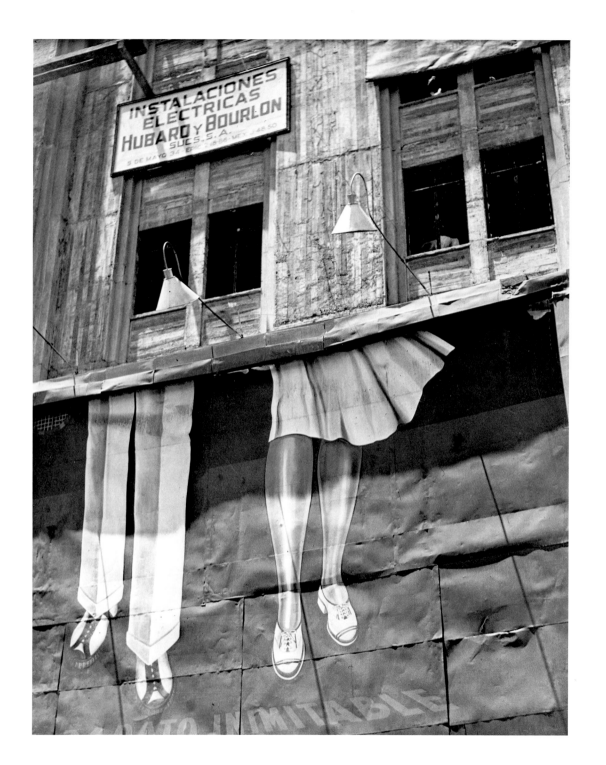

17

rochial in his approach. At once ironic and emotional, sympathetic yet detached, Alvarez Bravo's world view actively and eagerly courts, endorses, and encompasses the contradictions and complexities of the culture to which it is symbiotically bound. If it were possible to restore dignity to the term "ethnocentric," then I would apply that word to his body of work—for it accepts Mexico and its people as a viable and sufficient metaphor for life itself.

Such an acceptance—far from uncritical, but equally far from cynicism and alienation—is the source of his work's integrity and power. His work makes no plea, sounds no alarms over transient plights, and polemicizes no issues. The people of Manuel Alvarez Bravo's images bear as their birthright (often their only one) the knowledge that they will feed their native land with their toil and their flesh as their ancestors have done back into pre-history.[4] That is their burden, and their badge. Despite what economics may indicate, no matter what politicians and businessmen and the military may enforce, the land—and the culture—is theirs. Death is the equalizer.

But life is a dream.

A.D. Coleman
New York City

NOTES

This essay is an updated and expanded version of one that originally appeared in *Artforum*, April 1976 and was reprinted in A.D. Coleman, *Light Readings*, New York: Oxford University Press, 1978.

1. Emily Edwards, *Painted Walls of Mexico: From Prehistoric Times until Today*, photographs by Manuel Alvarez Bravo, Austin: University of Texas Press, 1968, p. 145.

2. Although out of print, see, for example, Jane Livingston, *M. Alvarez Bravo,* Boston and Washington, DC: David R. Godine and the Corcoran Gallery of Art, 1978, and *Manuel Alvarez Bravo: fotografías 1928–1968*, text by Juan Garcia Ponce, Mexico: Instituto Nacional de Bellas Artes, D. F.: Comite Organizador de Los Juegos de Las XIX Olimpiada, 1968. Retrospectives have been held during the past several years at the International Center of Photography in New York and the Musée d'Art Moderne de la Ville de Paris, with a catalog of the 303-print exhibition, *Manuel Alvarez Bravo: 1920–1986,* Paris: Paris Musées/Paris Audio Visuel, 1986.

3. This particular image has a historical forebear in O. G. Rejlander's "The Bachelor's Dream," and at least one offspring in the third image from the last in Ralph Gibson's *Déjà-Vu.*

4. Alvarez Bravo's own connection with the same land pervades his images. He says of himself, "I was born in the city of Mexico, behind the Cathedral, in the place where the temples of the ancient Mexican gods must have been built, February fourth, 1902." In Fred R. Parker, *Manuel Alvarez Bravo*, Pasadena, California: Pasadena Art Museum, 1971, p. 48.

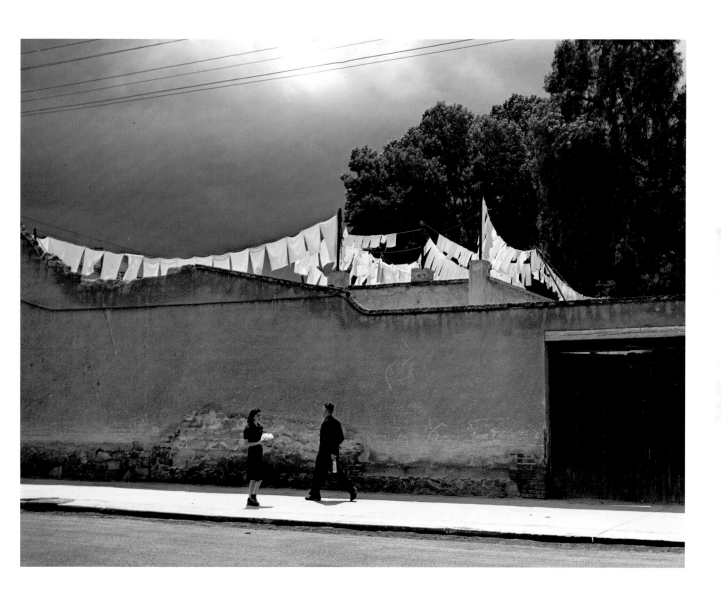

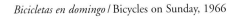

Bicicletas en domingo / Bicycles on Sunday, 1966

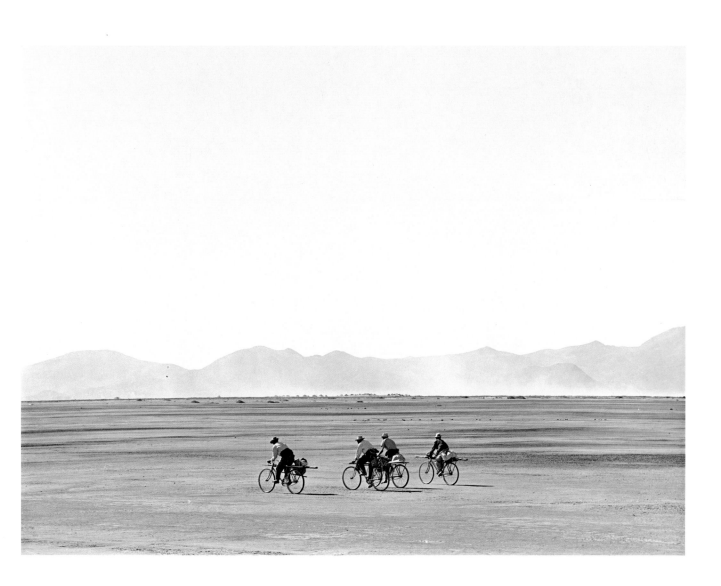

Árbol que partió un rayo / Tree struck by lightning, 1956

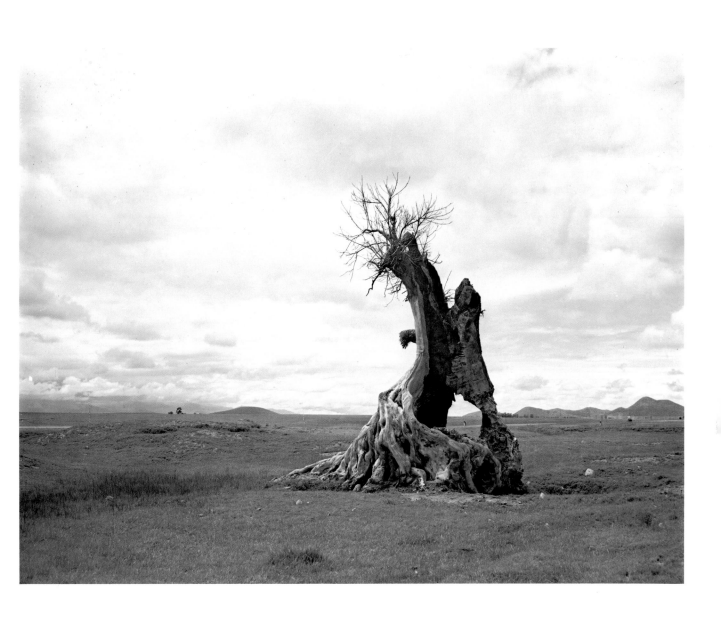

Paisaje Chamula / Chamula landscape, 1967

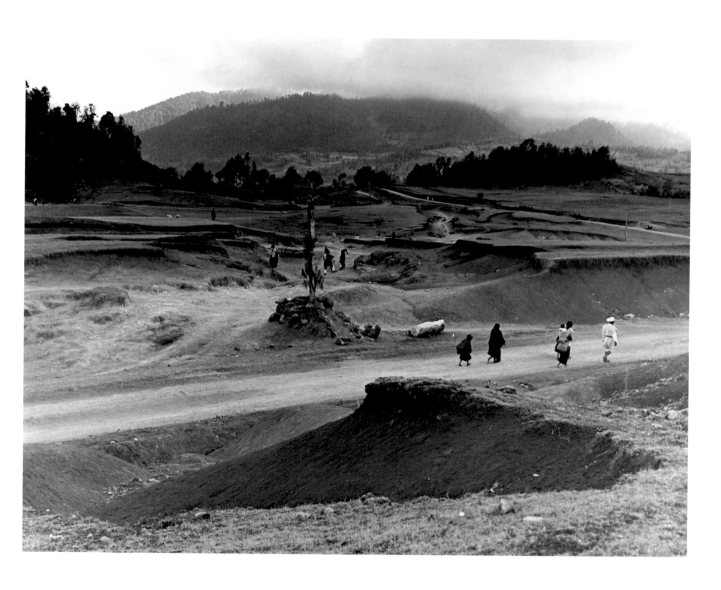

Violín Huichol / Huichol violin, 1965

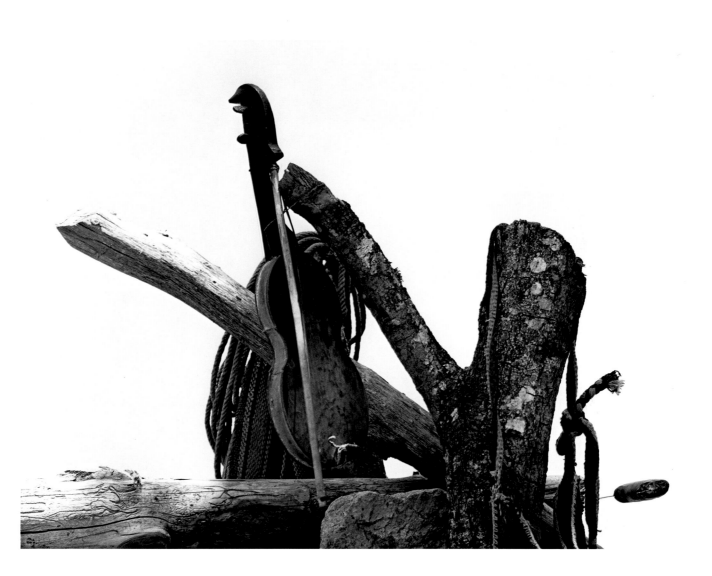

El soñador / The dreamer, 1931

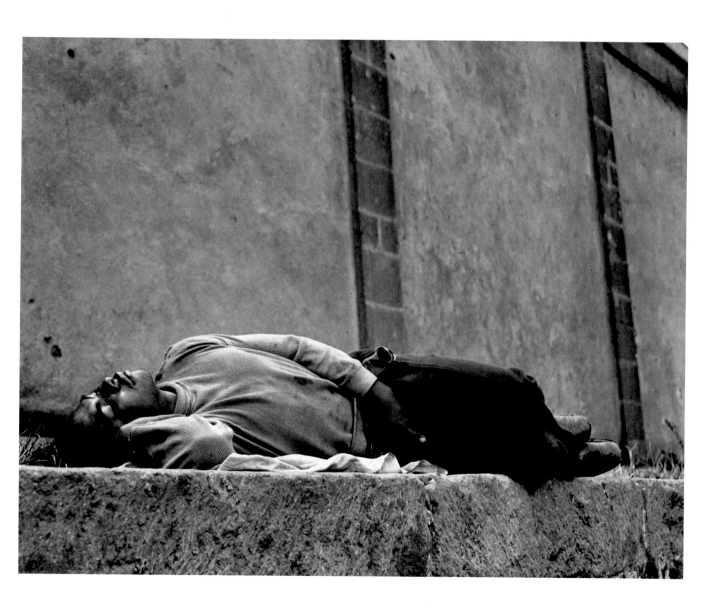

Tumba reciente / Recent grave, 1939

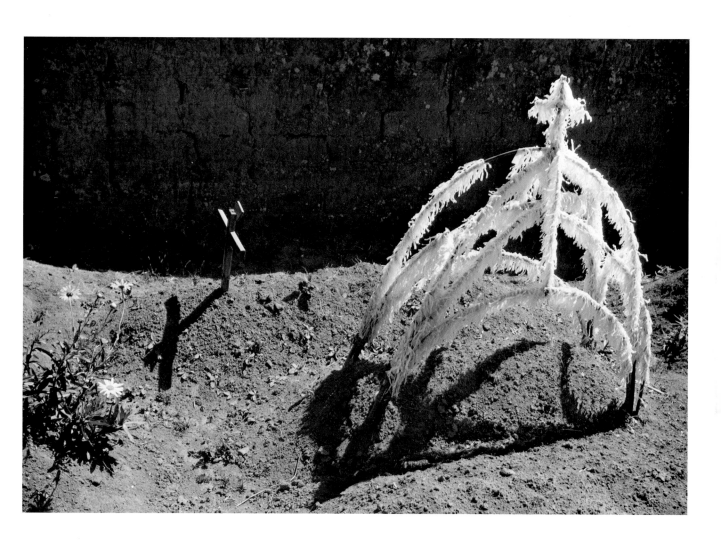

31

Las espinas / Thorns, 1940s

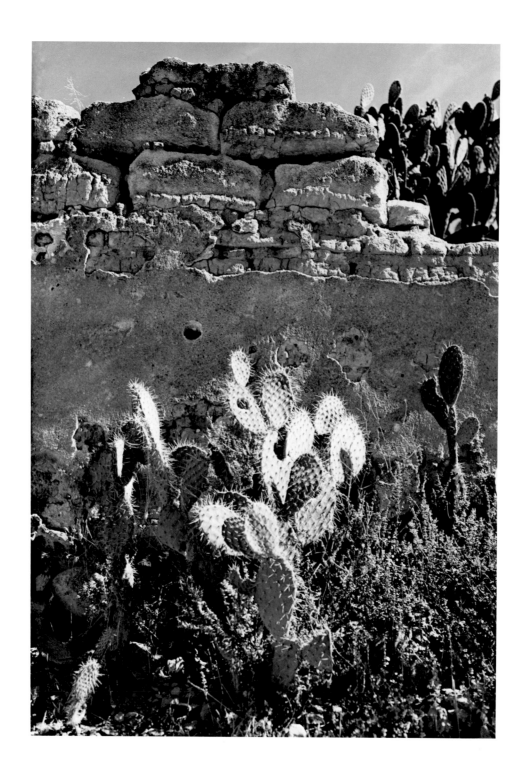

Magueyes heridos / Wounded agaves, 1950

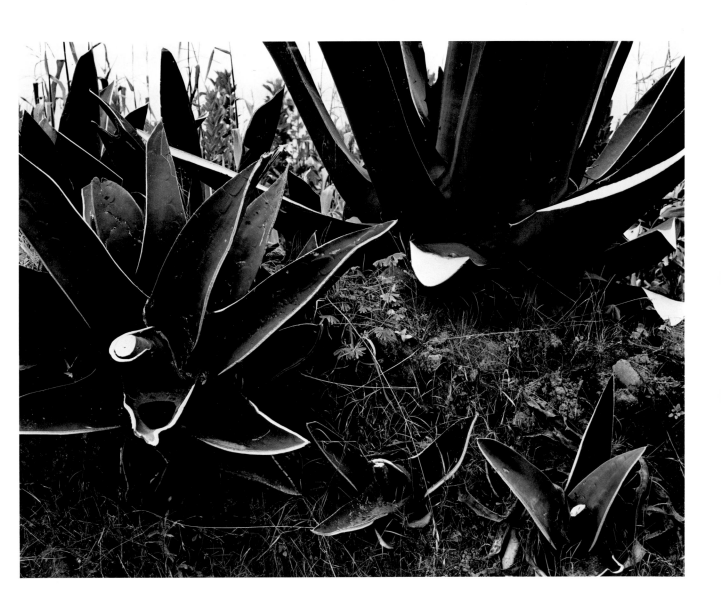

Xipe, la segunda / Xipe, the second, 1982

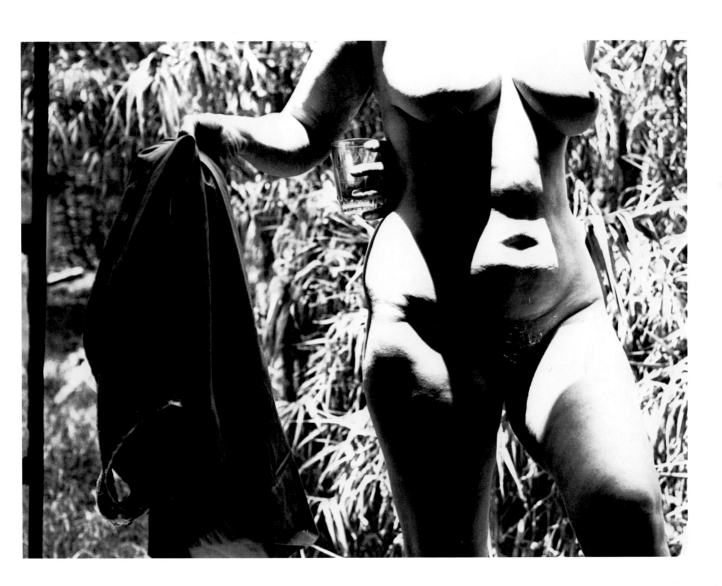

Ventana al coro / Window to the choir, 1936

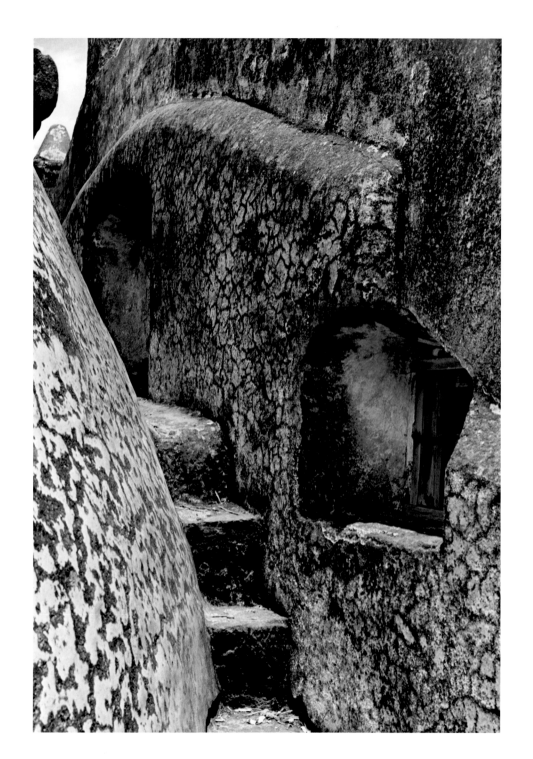

Instrumental / Instrumental, 1931

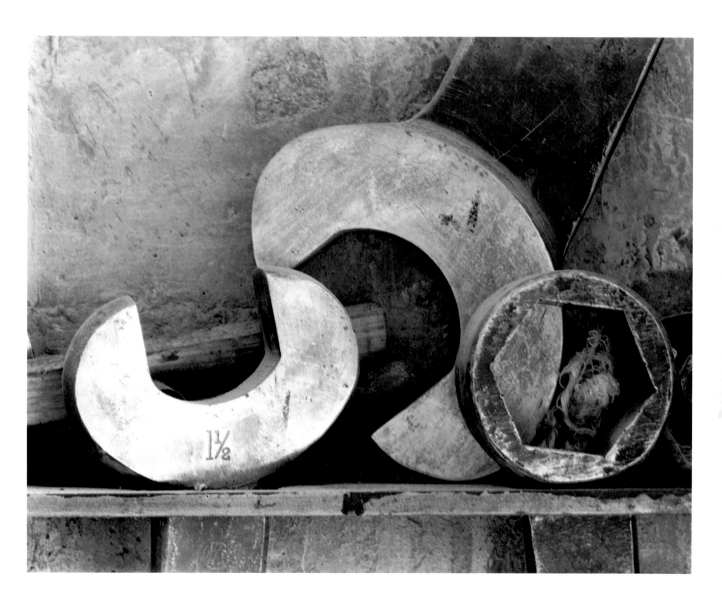

Diego Rivera, 1930-40

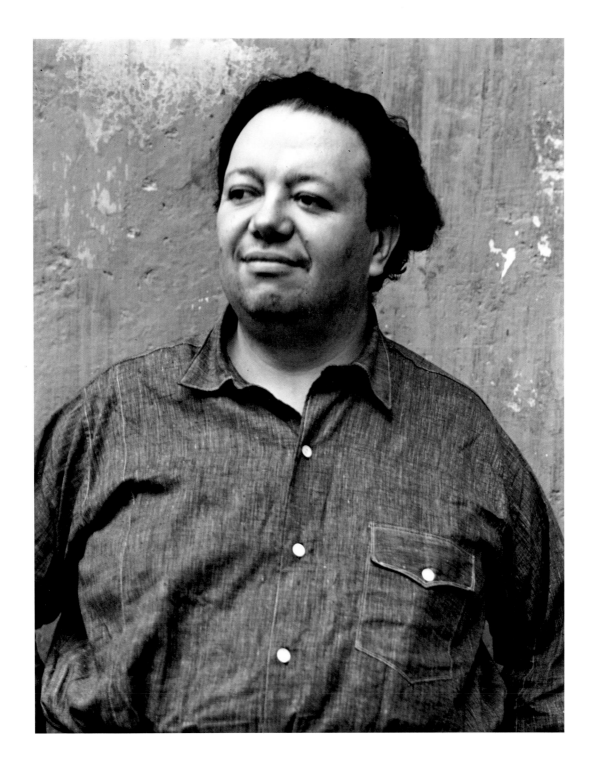

43

Leon Trotsky, 1930-40

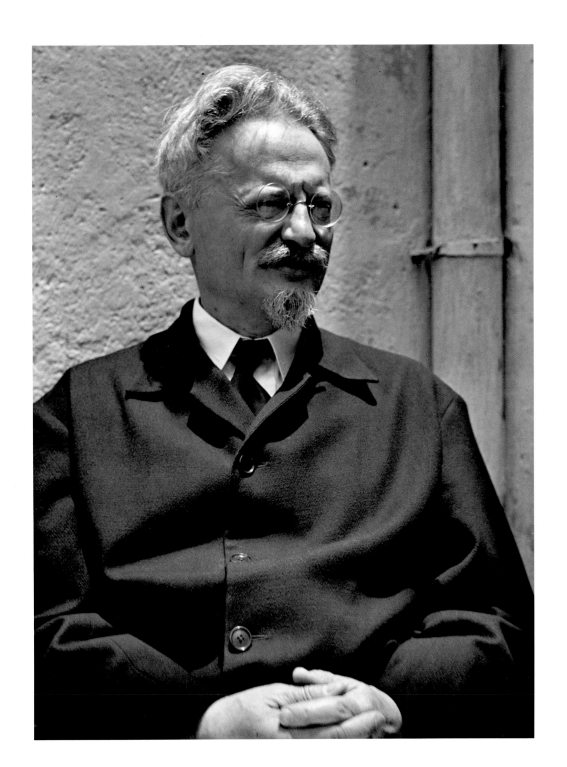

Retrato desagradable / Unpleasant portrait, 1945

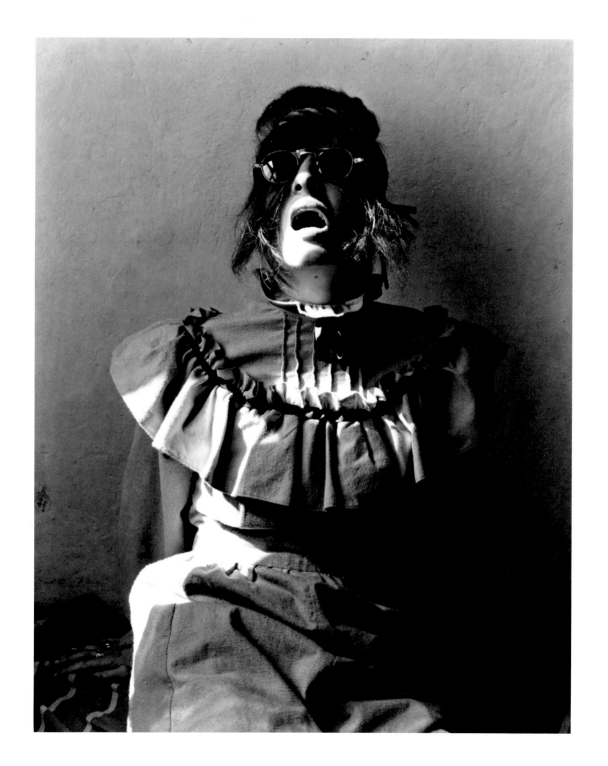

La de las Bellas Artes / The one of the Fine Arts, 1933-34

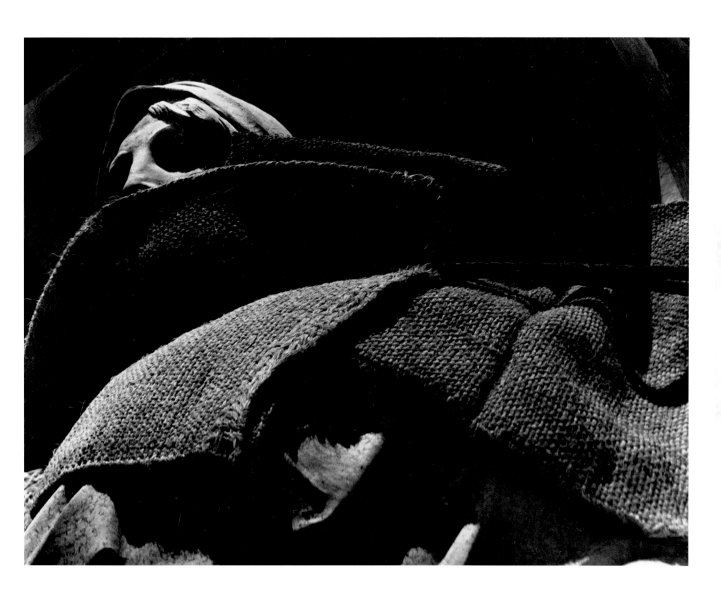

El trapo negro / The black cloth, 1986

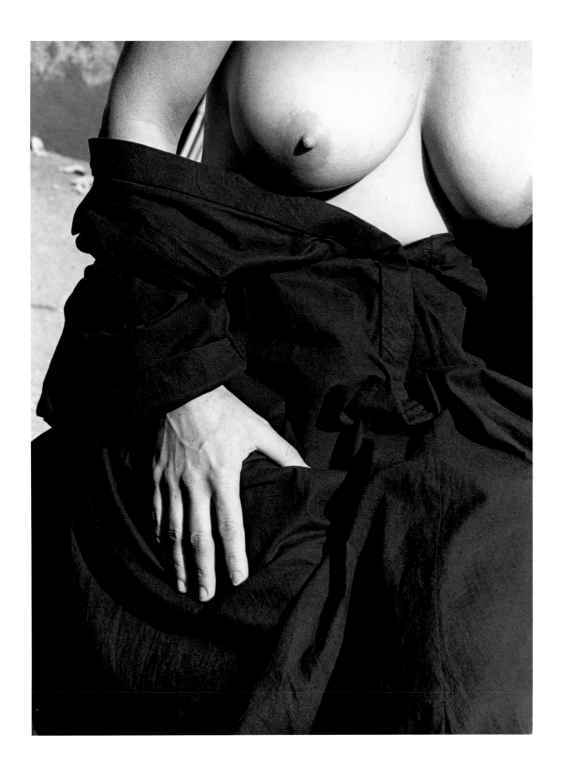

Retrato de lo eterno / Portrait of the eternal, 1935

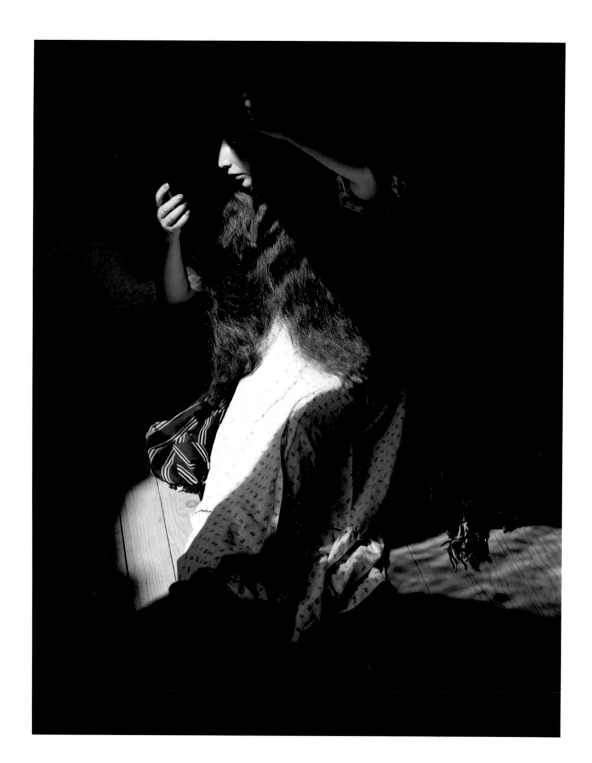

Caballo de madera / Wooden horse, 1928

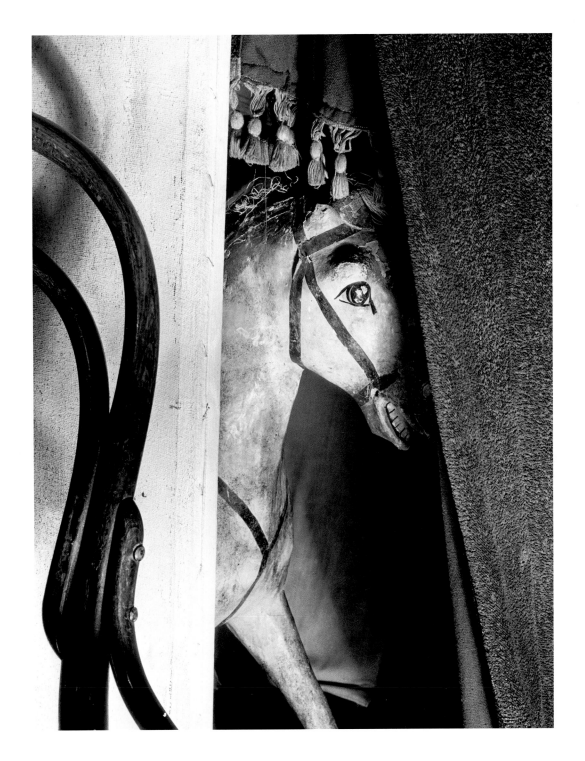

Día de todos los muertos / Day of the dead, 1933

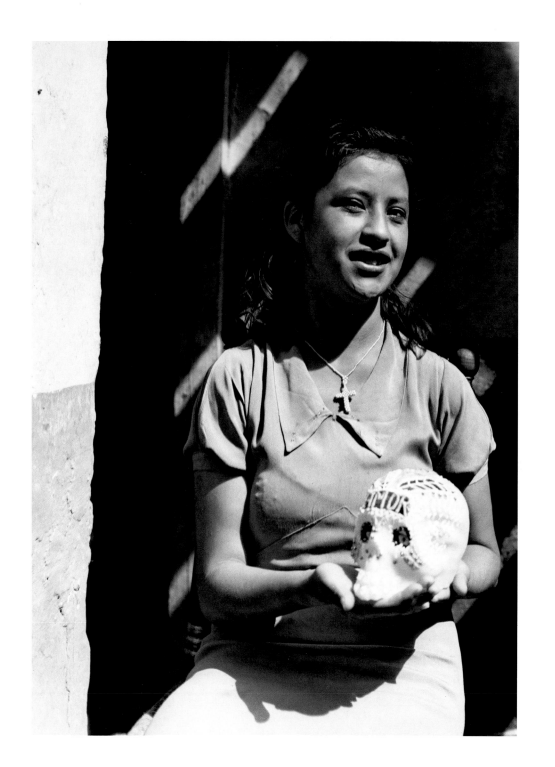

Obrero en huelga, asesinado / Striking worker, assasinated, 1934

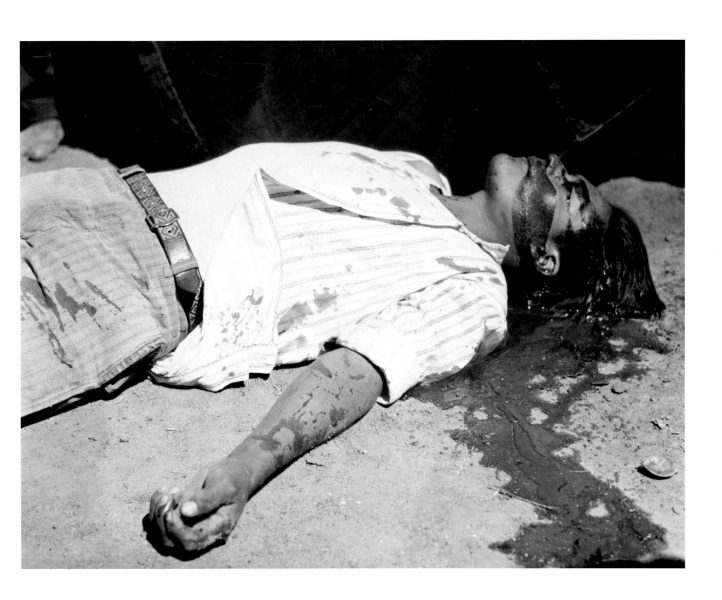

Corona de espinas / Crown of thorns, 1925

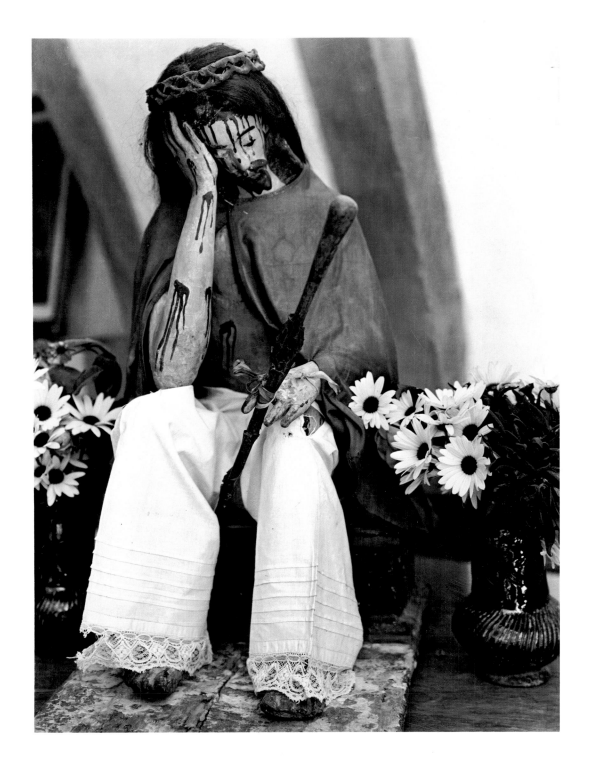

Los creadores, los formadores / The creators, the shapers, 1940-42

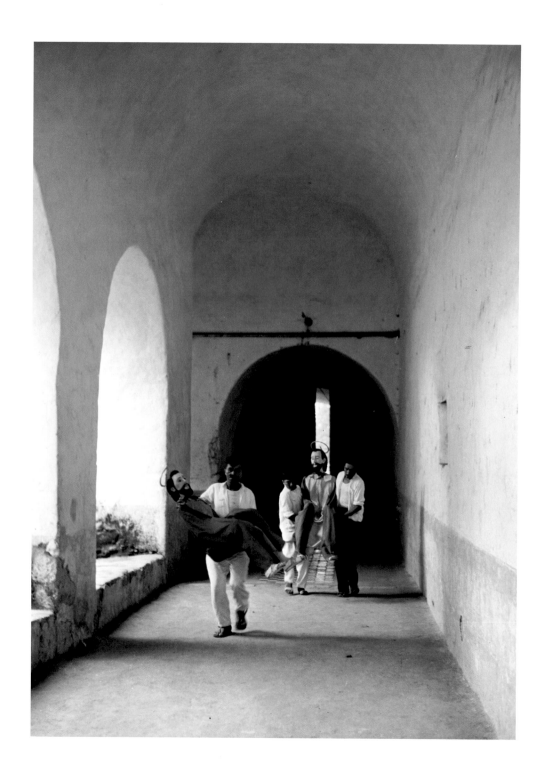

Ángeles en camión / Angels in truck, 1930

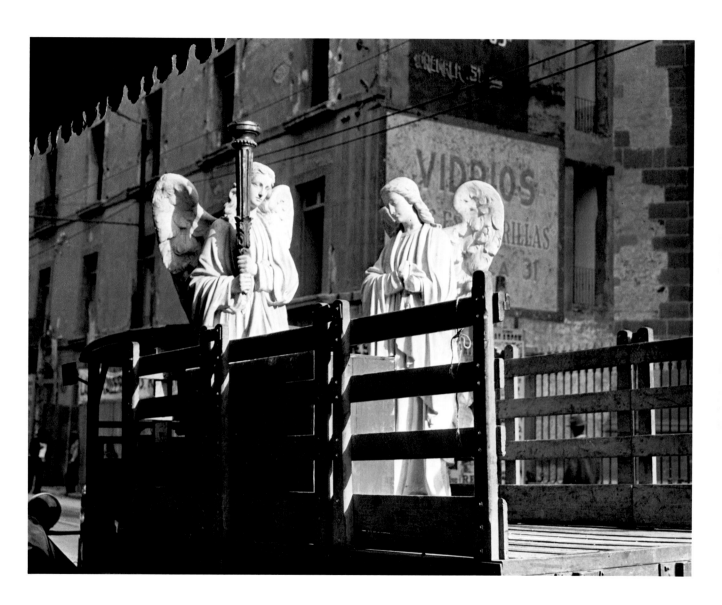

Niño maya de Tulum / Mayan boy of Tulum, 1942

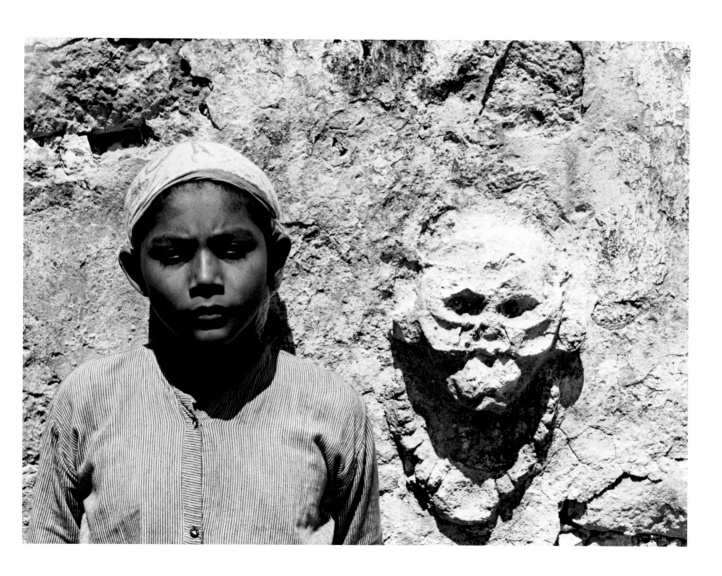

Retrato póstumo / Posthumous portrait, 1939

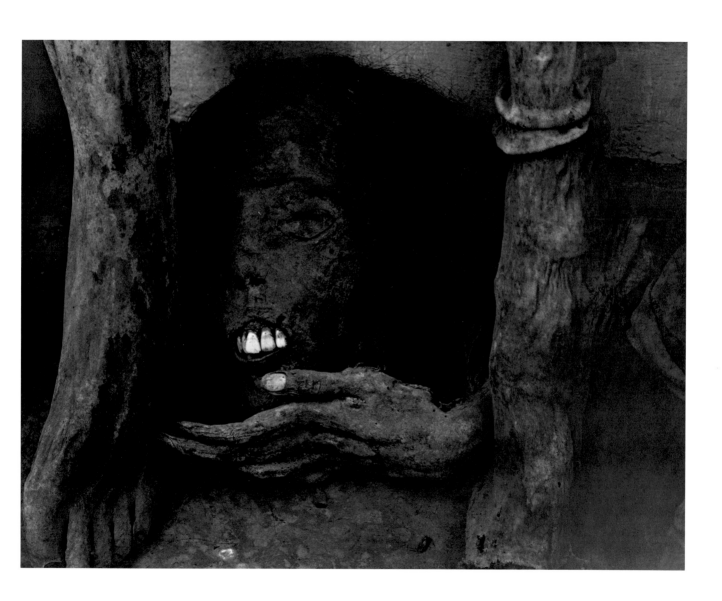

Un poco alegre y graciosa / Somewhat gay and graceful, 1942

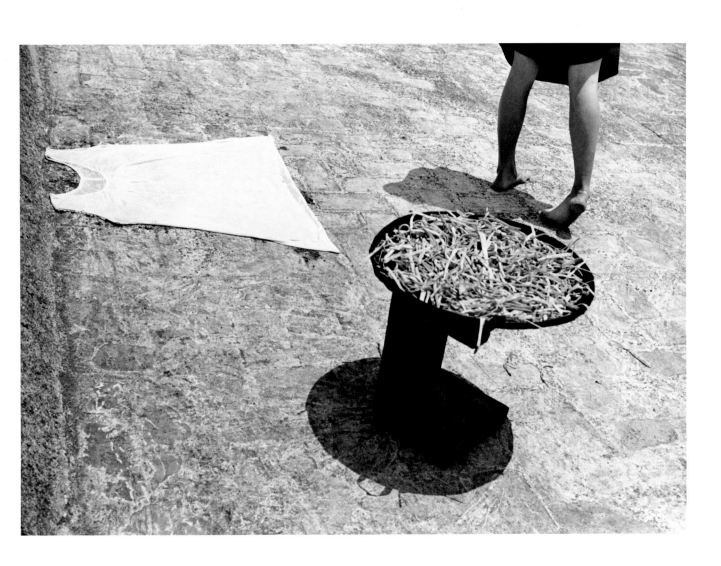

El ensueño / Daydreaming, 1931

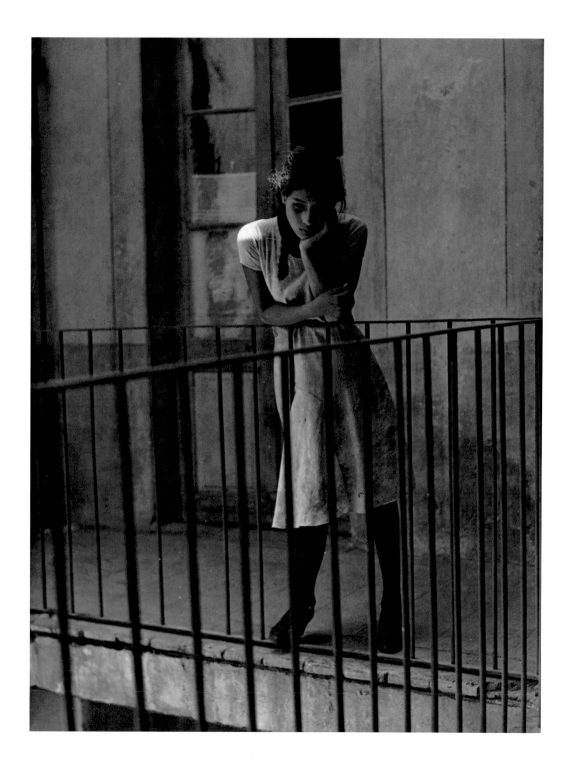

El perro veinte / Dog number twenty, 1958

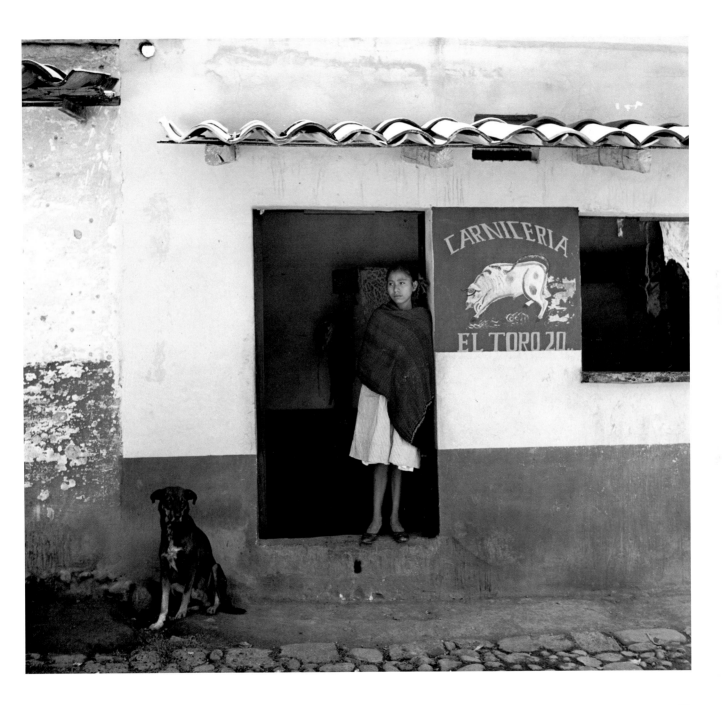

Luz restirada / Stretched light, 1947

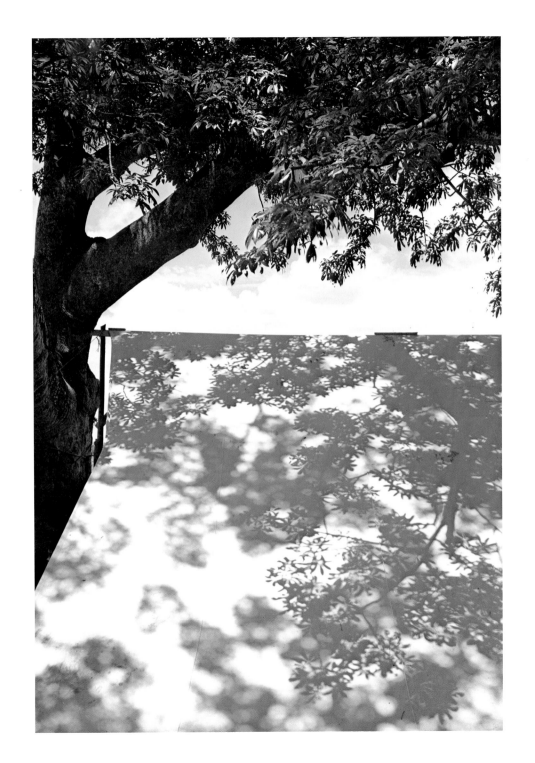

Coronada de palmas / Crowned by palms, 1936

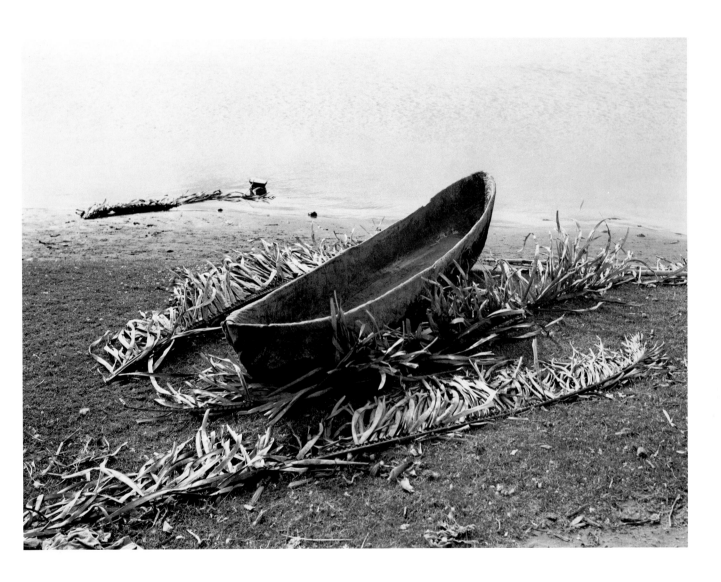

La quema / Kiln, 1957

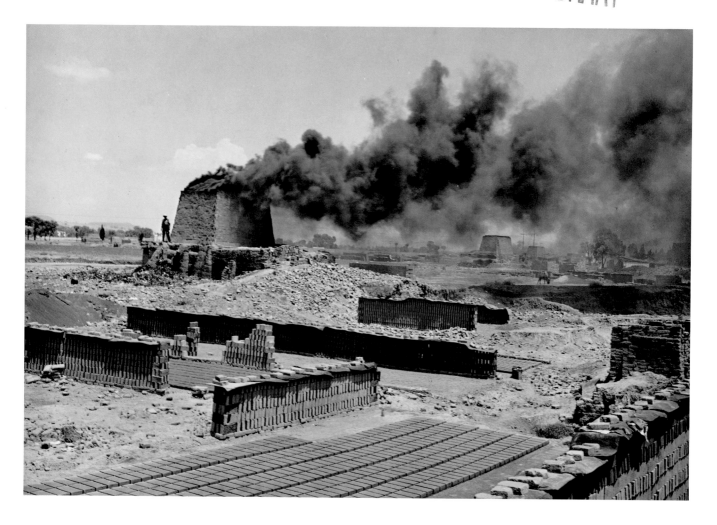

Salinero / Saline worker, 1939

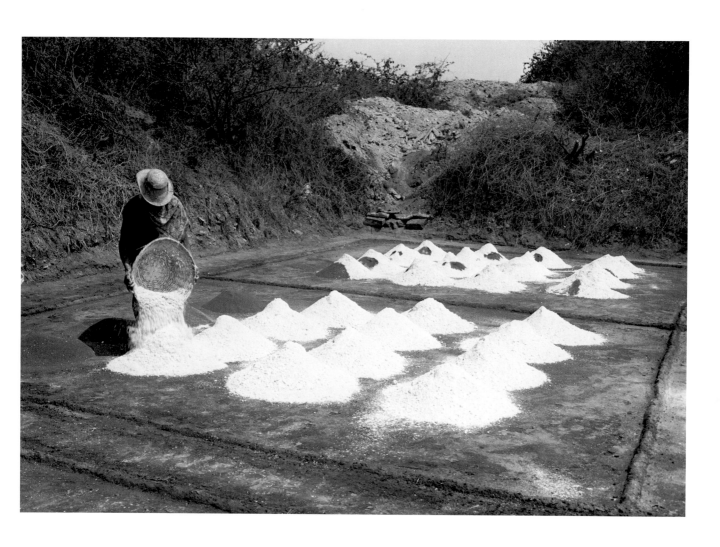

Trabajadores del trópico / Workers of the tropics, 1944

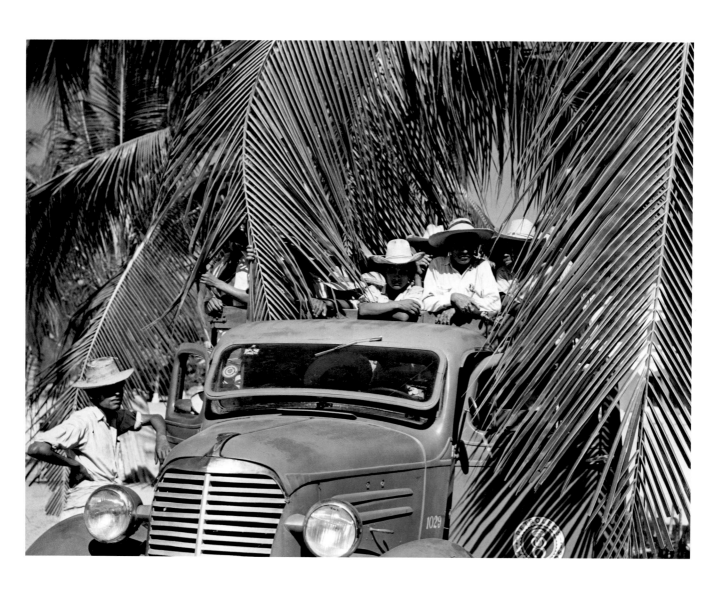

Trampa puesta / Placed trap, 1930s

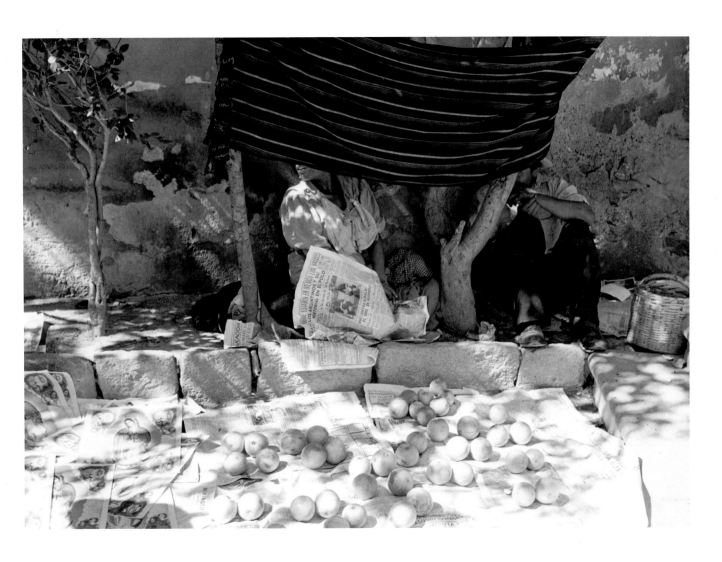

CHRONOLOGY

1902. Born February 4, Mexico City.

1915–16. Quits school and works as a copy clerk.

1916–30. Works for the Mexican Treasury Department in various capacities.

1917–18. Takes night classes in literature; also studies painting and music at the Academia Nacional de Bellas Artes de San Carlos.

1922. First becomes interested in photography and the indigenous art of Mexico.

1923. Meets the German photographer Hugo Brehme.

1924. Buys his first camera and takes portraits of his colleagues.

1926. Wins first prize at a regional exposition in Oaxaca.

1927. Meets the photographer Tina Modotti who encourages his work.

1929. Instructor in Photography, Escuela Central de Artes Plásticas. At instigation of Modotti, sends some work to Edward Weston, who encourages him to continue in photography. Meets Rufino Tamayo.

1930. Quits job at the Ministry of Finance; becomes freelance photographer. Through Modotti and Frances Toor, editor of *Mexican Folkways,* meets Mexican muralists, including Diego Rivera, David Alfaro Siqueiros, José Clemente Orozco, and photographs their work for the next several years.

1931. Receives First Prize, concurso de fotografía, Fábrica de Cemento, La Tolteca.

1938–40. Professor of photography at the Academia Na-
cional de Bellas Artes de San Carlos. Meets André Breton and becomes interested in surrealism.

1940–42. Runs a commercial photography studio in Mexico City.

1943–59. Works as photographer and camera operator for Sindicato de Trabajadores de la Producción Cinematográfica de México (Mexican Film Workers Guild).

1959. With Leopoldo Mendez, Rafael Carrillo, and Carlos Pellicer, founds Fondo Editorial de la Plástica Mexicana, with the goal of publishing books on Mexican art.

1974. Receives the Sourasky Art Prize.

1975. Receives the National Art Prize (Mexico) and a John Simon Guggenheim Memorial Fellowship.

1976. The Museo de Arte Moderno, Mexico City, installs a room devoted to a selection of his work, which is on display through 1982.

1980. Leaves Fondo Editorial de la Plástica Mexicana to develop a Mexican Museum of Photography. Becomes honorary member of the Academia de Artes, Mexico.

1984. Receives the Swedish Victor and Erna Hasselblad Prize.

1986. The Museum of Mexican Photography opens March 26.
Receives Brehm Memorial Award from the Rochester Institute of Technology.

1987. Honored as Master of Photography by the International Center of Photography.

SELECTED EXHIBITIONS

1926. Oaxaca, Mexico, regional exhibition.

1932. Galería Posada, Mexico City, July 28–August 10.

1935. Palacio de Bellas Artes, Mexico City, March 11–20. With Henri Cartier-Bresson.
Julien Levy Gallery, New York. With Walker Evans and Henri Cartier-Bresson.

1936. Hull House, Chicago, March 22–31.

1939. Galerie Renou et Colle, Paris, "Souvenir du Mexique." Retrospective exhibition of Mexican art organized by André Breton.
Universidad Nacional de Mexico, Mexico City.

1940. Galería de Arte Mexicano, Mexico (Galería Inés Amor), Mexico City, "Exposición Internacional del Surrealismo," January–February.

1942. Photo League, New York, January 10–February 1.

1943. Philadelphia Museum of Art, "Mexican Art Today."
Art Institute of Chicago, December 10–January 16.

1945. Sociedad de Arte Moderno, Mexico, "Manuel Alvarez Bravo—Fotografías," July. Catalog with essays by Manuel Alvarez Bravo, Diego Rivera, Xavier Villaurrutia, and Gabriel Figueroa.
Museum of Modern Art, New York, with Paul Strand, Walker Evans, and August Sander.

1955. Museum of Modern Art, New York, "The Family of Man," January 24–May 8, world tour through 1959.

1957. Salón de la Plástica Mexicana, March 7–26.

1966. Galería de Arte Mexicano (Galería Inés Amor), Mexico City, May 9–28.

1968. Palacio Nacional de Bellas Artes, Mexico City, XIX Olympiad. "Manuel Alvarez Bravo—Fotografías 1928–1968," June 25–August 10.

1971. Pasadena Art Museum, California, May 4–June 20.
Museum of Modern Art, New York.

1972. Witkin Gallery, New York, July 26–August 27.
Palacio Nacional de Bellas Artes, Mexico City, "Manuel Alvarez Bravo: 400 fotografías," July–September.

1973. Casa de la Cultura, Juchitán, Oaxaca, Mexico.

1974. Galería José Clemente Orozco, Mexico, "Cien fotografías y paisajes inventados."
Art Institute of Chicago, April 6–June 2. From the collection of the Instituto Nacional de Bellas Artes, Mexico City and the Palacio Nacional de Bellas Artes. Travels to the University of Massachusetts Art Gallery.

1975. Museo de Arte Moderno, Caracas, Venezuela.
Witkin Gallery, New York, May–June.
Galería Juan Martín, Mexico, March 10–July 19.
Pan Opticon Gallery, Boston, October 10–30.

1976. La Photogalerie, Paris, April–July. Travels to Musée Nicéphore Niepce, Chalon-sur-Saône and the Galerie Municipale du Château d'Eau, Toulouse.
Museo de Arte Moderno, Mexico City.

1977. Galería Juan Martín, Mexico, June–July.
Photographer's Gallery, London.
Corcoran Gallery, Washington, DC. Travels.
University of Arizona, Tucson, "Contemporary Photography in Mexico."

1979. Musée Réattu, Arles, "Rencontres Internationales de la Photographie."

1980. Galerie Agathe Gaillard, Paris.
Academia de Artes de Mexico.

1981. Witkin Gallery, New York.

1982. Museo de Arte Moderno, Mexico.

1983. Israel Museum, Jerusalem, July. Travels to the New Museum, Bradford, England, the Museum of Modern Art, Oxford, and Photographer's Gallery, London.

1984. Third Colloqium of Latin American Photography, Havana, Cuba, November.

1985. Salas Pablo Ruiz Picasso, Biblioteca Nacional, Madrid, May.

1986. Galería de Exposiciones del Palacio de Bellas Artes, Mexico, February–March. Fiftieth anniversary exhibition with Henri Cartier-Bresson.
Hartnett Gallery, Rochester Institute of Technology.
Musée d'Art Moderne de la Ville de Paris, October 8–December 10.

1987. International Center of Photography, New York, April 24–June 14.

SELECTED BIBLIOGRAPHY

1930. Maximo Brétal. Untitled article. *Excelsior* (Mexico) November 13.

1935. *Manuel Alvarez Bravo.* Text by Luis Cardoza y Aragón and Langston Hughes. Mexico City.

1937. Bertram D. Wolfe and Diego Rivera. *Portrait of Mexico.* New York: Covici Friede. Photographs by Alvarez Bravo, Tina Modotti, and Lupercio.

1939. André Breton. "Souvenir du Mexique." *Minotaure* (Paris) 3 (12–13):29–52 (May).
Benjamin Péret. "Ruines: Ruine des Ruines." *Minotaure* (Paris) 3 (12–13):57 (May).
Xavier Villaurrutia. "Manuel Alvarez Bravo." *Artes Plásticas* (Mexico) 1 (Spring).

1945. David Alfaro Siqueiros. "Movimiento y Meneos de Arte en México." *ASI* (Mexico) 249 (August 18):12–13.

1953. Minor White. "Manuel Alvarez Bravo." *Aperture* 1(4):28–36.

1966. Emily Edwards. *Painted Walls of Mexico.* Austin: University of Texas Press. Photographs by Manuel Alvarez Bravo.
Margarita Nelken. "Manuel Alvarez Bravo." *Excelsior* (Mexico) June 3.
William Philip Spratling. *More Human Than Divine.* Mexico City: Universidad Nacional Autonome de Mexico.

1968. *Manuel Alvarez Bravo Fotografías 1928–1968.* Mexico City: Instituto Nacional de Bellas Artes. Selection of poems text by Juan García Ponce.
Paul Strand. "Manuel Alvarez Bravo." *Aperture* 13 (4): 2–12.

1970. Robin Grace. "Manuel Alvarez Bravo." *Album* (London) 9:2–14 (October).

1971. David Cordoni. "Manuel Alvarez Bravo." *Artweek* 4 (24): 9–10 (July 7).
John Littlewood. "Bravo's Mexican Pictures: Photographic Timelessness." *Christian Science Monitor* April 5, p. 22.
Fred R. Parker. *Manuel Alvarez Bravo.* Pasadena: Pasadena Art Museum.
Leland Rice. "Mexico's Master Photographer." *Artweek* 4 (20): 22 (May 22).

1972. Fred R. Parker. "Manuel Alvarez Bravo." *Camera* (Lucerne) 51:34–43 (January).

1974. Richard Pare. "Manuel Alvarez Bravo—Hieratic Images of Life and Death." *New Art Examiner* (Chicago) 1 (7): 9 (April).

1975. Michael André. "Photography: Manuel Alvarez Bravo." *ArtNews* 74 (7): 104 (September).

"El Arte Fotografico de Manuel Alvarez Bravo." *Revista de Bellas Artes* (Mexico) January–February.
Salvador Elizondo. "Manuel Alvarez Bravo." *Plural* (Mexico) 4 (11): 5, 77–78 (August).
Gene Thornton. "The Mexico of Alvarez Bravo." *New York Times* May 25, sec. 2, p. 25.
Peter Turner. "Manuel Alvarez Bravo." *Creative Camera International Yearbook,* eds. Colin Osman and Peter Turner. London: Coo Press, pp. 10–36.
Anne Middleton Wagner. "Manuel Alvarez Bravo at the University of Massachusetts Art Gallery." *Art in America* 63 (3): 77–78 (May–June).

1976. Gerry Badger. "The Labyrinth of Solitude: The Art of Manuel Alvarez Bravo." *The British Journal of Photography* 123 (6043): 425–428 (May 21).
A.D. Coleman. "The Indigenous Vision of Manuel Alvarez Bravo." *Artforum* 14 (8): 60–63 (April).
Michel Nuridsany. "Le Mexique sans folklore d'Alvarez Bravo." *Le Figaro,* April 26.
Octavio Paz. "Cara al Tiempo." *Plural* (Mexico) 58 (July): 43–45.
Martine Voyeux. "Voir, c'est un vice." *Le Quotidien de Paris,* May 13.

1977. Paul Hill and Tom Cooper. "Manuel Alvarez Bravo." *Camera* 56 (5): 36–38 (May); 56 (8): 35–36 (August).

1978. Jessica Alonso. "From the Soul of Mexico to the Heart of America." *Boston Globe,* March 29.
Stu Cohen. "Photography: Shooting the Heart of Mexico." *Boston Phoenix,* April 4, sec. 3, p. 9.
Jane Livingston et al. *M. Alvarez Bravo.* Boston: Godine, and Washington, DC: Corcoran Gallery of Art.
Joan Murray. "Manuel Alvarez Bravo: 'Como Siempre.'" *Artweek* 9 (19): 1, 11 (May 13).
René Verdugo and Terrence Pitts. "Manuel Alvarez Bravo." *Contemporary Photography in Mexico.* Tucson: University of Arizona.

1980. Vivienne Silver. "The Artistic Development and Evolution of Manuel Alvarez Bravo, Mexican Photographer, As Seen Through His Nudes." Masters thesis, University of Arizona.

1983. Octavio Paz. *Instante y Revelación.* Mexico: Fonapas-Círculo Editorial. Texts and poems with photographs by Manuel Alvarez Bravo.
Nissan N. Perez and Ian Jeffrey. *Dreams, Visions, Metaphors.* Jerusalem: Israel Museum.

1987. *Manuel Alvarez Bravo.* Paris: Paris Musées/Paris Audio Visuel.

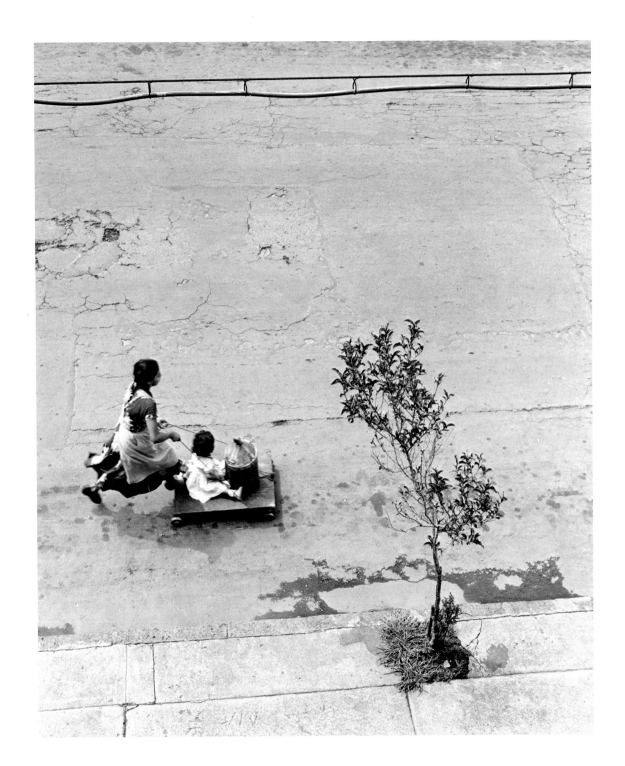

APERTURE Masters of Photography

The Aperture Masters of Photography series provides a comprehensive library of photographers who have shaped the medium in important ways.

Each volume presents a selection of the photographer's greatest images. 96 pages, 8 x 8 inches, 42 black-and-white photographs; hardcover, $12.50. The set of twelve titles, a $150 value, is available for $99.95 and can be purchased through fine bookstores.

If unavailable from your bookseller, contact Aperture, 20 East 23rd Street, New York, NY 10010. Toll Free: (800) 929-2323; Tel: (212) 598-4205; Fax: (212) 598-4015.

A complete catalog of Aperture books is available on request.

BERENICE ABBOTT

Essay by Julia Van Haaften

EUGENE ATGET

Essay by Ben Lifson

MANUEL ALVAREZ BRAVO

Essay by A. D. Coleman

HENRI CARTIER-BRESSON

Essay by Henri Cartier-Bresson

WALKER EVANS

Essay by Lloyd Fonvielle

ANDRE KERTESZ

Essay by Carole Kismaric

MAN RAY

Essay by Jed Perl

AUGUST SANDER

Essay by John von Hartz

ALFRED STIEGLITZ

Essay by Dorothy Norman

PAUL STRAND

Essay by Mark Haworth-Booth

WEEGEE

Essay by Allene Talmey

EDWARD WESTON

Essay by R. H. Cravens